*Above: Adelaide city at dusk, from Mount Osmond.*
*Right: The Adelaide Symphony Orchestra performing in Elder Park.*

*Adelaide viewed from the north. The Festival Centre stands on the south bank of Torrens Lake.*

4

*Above: Adelaide Post Office stands in King William Street.*
*Far left: The Adelaide Casino and Railway Station, North Terrace.*
*Centre left: Old Parliament House, built in 1855, is now the State History Centre.*
*Left: Parliament House (right) is built of Kapunda marble.*
*Above right: John Dowie's fountain in Victoria Square symbolises the Murray, Torrens and Onkaparinga Rivers, which supply Adelaide with water.*

# ADELAIDE
## A WELL-DESIGNED CITY

Adelaide city centre covers one and one-half square kilometres and has been laid out following Surveyor General Light's plan, on a simple grid pattern around five squares. Wide thoroughfares, such as King William Street and North Terrace, are bordered by modern buildings and by majestic nineteenth-century edifices. To the north of the city, separated by a lake formed by the impeded waters of the River Torrens, is gracious North Adelaide, whose centre is Wellington Square. Adelaide city centre and North Adelaide are surrounded by extensive and well-kept parklands, whose use includes botanic and zoological gardens, sports grounds, Victoria Park Racecourse, the Municipal Golf Course and many recreational areas.

# ADELAIDE
## Festival Centre

The Adelaide Festival Centre, home of Adelaide's Festival of Arts, stands just south of Elder Park, between Parliament House, the Constitutional Museum and Torrens Lake. The complex was completed in 1977 and includes a multi-purpose concert hall, the Playhouse and the Space Theatres and catering facilities, surrounded by a broad plaza. The internationally-recognised Adelaide Festival of Arts is held in March of every even-numbered year. The very popular Come Out Youth Arts Festival is held in May of every odd-numbered year.

*Above: The sculptures in the plaza of the Adelaide Festival Centre, which is 1.2 hectares in extent, are the work of O.H. Hajek.*
*Right: The Adelaide Festival Centre, focus of a city's rich cultural life.*

7

# ADELAIDE
## City of churches

Adelaide rose in an era when cathedrals and churches were an integral part of a city's design and boasts some of Australia's finest centres of worship. The foundation stone of the Anglican Holy Trinity Church in North Terrace was laid by Governor Hindmarsh in January 1838 and it was known in early days as "the military place of worship". North Adelaide's Congregational Church stands in Brougham Place and was completed in 1872. The foundation stone of St Peter's Anglican Cathedral was laid in 1869 and building works were finally completed in 1904. The cathedral is built of Tea Tree Gully sandstone and Murray Bridge firestone and dominates the northern end of King William Road. Its peal of bells is especially fine. The Mosque in Little Gilbert Street was built in 1889, as a place of worship for Afghan camel drivers.

*Above: St Peter's Cathedral, North Adelaide.*
*Right: Adelaide city, viewed from North Adelaide.*

# ADELAIDE
## Gardens and Parks

Adelaide's Botanic Gardens and State Herbarium were officially opened in 1857 and form part of the extensive parklands encircling the city. The Herbarium and the Palm House are classic examples of Victorian architecture and the gardens feature a Museum of Economic Botany. The spectacular Bicentennial Conservatory, the largest in the southern hemisphere, contains around 4,000 tropical plants. Other green spaces surrounding the city include the Adelaide Himeji Garden, on the corner of South Terrace and Glen Osmond Road, which was built to symbolise the bonds of friendship between the city and the Himeji region of Japan. Elder Park, on the south bank of Torrens Lake, is the site of the Festival Centre and offers launch cruises and paddleboats for hire. The extensive East Parklands contain many areas for relaxation and sporting activities.

*Above: The Adelaide Bicentennial Conservatory contains a tropical rainforest environment.*

10

*Main picture, left: The Palm House, a glasshouse opened in 1877 and restored in 1995, is thought to be the only one of its kind left in the world.
Inset top left: Looking from the Rotunda in Elder Park to the Festival Centre and the city.
Above top: The extensive parklands in Adelaide provide cool green spaces for relaxation.
Above: The beautification of the banks of the River Torrens attracts Adelaide people for exercise and recreation.*

*A view across Torrens Lake, which was formed by impeding the flow of the River Torrens, to the city of Adelaide.*

## The River Torrens

In the first years of settlement, the people of Adelaide drew their water from the River Torrens. The river was dammed in 1881 and its banks were then landscaped. Today, the Torrens is regulated by weirs to form Torrens Lake, which divides Adelaide from North Adelaide and offers fifty hectares of placid water bordered by parklands. The Victoria, Adelaide, Albert and Hackney Bridges span the river within the city boundaries. The Torrens is used for sport and recreation and pedal boats can be hired near the Adelaide and Victoria Bridges. The River Torrens Linear Park is a remarkable concept which, when completed, will follow the banks of the river from the hills to the sea and offer many recreational opportunities.

*Left: Adelaide and Torrens Lake at night.*
*Above: The River Torrens is a recreational feature of Adelaide.*

### ADELAIDE, A CITY FOR PEOPLE

*Above: Rundle Street East is a colourful shopping strip, with its outdoor cafés and lovely old bluestone and iron lace buildings.*
*Far left: Wall art decorates a city building.*
*Left: A fruit stall offers flowers and garden produce in Rundle Mall, a paved pedestrian thoroughfare.*

*Top right: The Gawler Place–Rundle Mall intersection, a busy shopping precinct.*
*Right: The Adelaide Arcade, opened in 1885.*
*Far right: Silver spheres, created by Bert Flugelman, are a well-known feature of Rundle Mall.*

17

## The South Australian Museum

Sited in North Terrace, the South Australian Museum is noted for its Australian Aboriginal collections and cultural history collections. Other rewarding places to visit in North Terrace include the Constitutional Museum and the Art Gallery of South Australia. The State History Centre is housed in Old Parliament House, which was built in 1855.

*Top: The Lavington Bonython Fountain stands outside the South Australian Museum.*
*Above: The South Australian Museum offers many attractions for young people.*
*Left: "Light's Vision", a memorial to Colonel William Light, stands on Montefiore Hill.*

## North Terrace

A gracious boulevard, North Terrace is bordered by some of Adelaide's most significant buildings and beautified by stately trees, gardens and a wealth of statues and monuments. Amongst historically significant buildings here are the Mortlock Library of South Australia, Adelaide University, Parliament House and the Railway Station and Casino.

*Top left: The South African War Memorial, on the corner of North Terrace and King William Road, commemorates South Australians who served in the Boer War (1899-1902).*
*Top right: The National Soldiers' War Memorial, on the corner of North Terrace and Kintore Avenue, shows a student, a farmer and a girl watched over by an armed angel representing the Spirit of Duty.*
*Above left: A statue of Scots poet Robert Burns stands on North Terrace, "the boulevard of learning".*
*Above right: This imposing figure is to be seen in Prince Henry Gardens, on North Terrace.*

19

*Below: This replica of H.M.S. "Buffalo" houses a restaurant and a nautical museum.*

*Right: The replica of H.M.S. "Buffalo" lies in Patawalonga boat haven, Glenelg.*

*Opposite: Lighthouse and historic buildings at Queens Wharf, Port Adelaide*

## николавNAUTICAL HISTORY

On 28 December, 1836, Captain John Hindmarsh arrived at Holdfast Bay in H.M.S. *Buffalo* with some 170 passengers and proclaimed the Province of South Australia. Today, a replica of the *Buffalo* lies near the original landing point at Glenelg. Port Adelaide was originally inadequate and larger vessels had to anchor at Holdfast Bay and land passengers and goods through the surf at Glenelg. When Governor Gawler arrived in 1838, he moved the port to deeper water. Port Adelaide became a municipality in 1855 and a city in 1901 and today offers nineteenth-century buildings, Port Dock Station Railway Museum, a Maritime Museum and a working lighthouse at Queens Wharf.

21

## GLENELG

Adelaide's excellent beaches include Glenelg, ten kilometres from the city centre. Here, on 28 December, 1836, beside the Old Gum Tree, the remains of which can still be seen, Governor Hindmarsh proclaimed the Province of South Australia. Adelaide's horse-drawn trams began in 1878 and were replaced by electric trams in 1909. Today, the last remaining tram route runs from Adelaide to the seaside delights and outdoor pleasures of Glenelg and the Glenelg Tram leaves the city for the seaside suburb every 15 minutes. Glenelg contains interesting colonial buildings and monuments, fine restaurants, cafes and excellent shops lining the main street, Jetty Road, which leads to the historic Glenelg jetty.

*Left: Glenelg jetty.*
*Below left: The last remaining Adelaide tram-route runs from the city to Glenelg.*
*Below: An aerial view of Glenelg.*

## A WORLD OF WINEMAKING

The Mediterranean climate of the Adelaide region means cool to mild, rainy winters and warm to hot summers. Grape vines flourish in this ambience, if irrigated or watered during the summer dry spell. Autumn each year brings the harvest, when grapes are picked, carted and crushed around the clock. The excellent vintages produced in the Barossa Valley and on the "Wine Coast" south of Adelaide, which includes McLaren Vale, have carried to the world the message that South Australia produces quality wines. Today, wine is a major South Australian export.

*Left: The town of Tanunda is said to be the cultural heart of the Barossa Valley.*
*Below left to right: Kaiser Stuhl winery, Barossa Valley; Yalumba Winery, Angaston, Barossa Valley; Seppelts and Sons winery, Barossa Valley; the essence of the Barossa Valley.*
*Above: Chateau Yaldara, Barossa Valley.*

ADELAIDE • Barossa Valley

25

## The Barossa Valley

In the early 1840s, settlers from Silesia, Prussia and Brandenburg entered the Barossa Valley, a fertile area around fifty kilometres north of Adelaide. They came to escape religious and economic persecution and they cultivated their new land with meticulous care. Today, the Barossa is a valley of flourishing vineyards, some forty wineries and picturesque towns such as Bethany, Tanunda, Nuriootpa, Lyndoch and Angaston. The biennial Barossa Vintage Festival is held in April and is a seven-day thanksgiving celebration. August brings the Barossa Classic Gourmet Weekend and October sees a Music Festival.

*Top: Winecasks in a Barossa Valley vineyard.*
*Above: In a Barossa Valley vineyard.*
*Right: Some fruits of the vine.*

## CRAFTS AND HISTORIES

The pages of history are turned back to show glimpses of a former lifestyle in many Barossa Valley towns, where nineteenth-century stone buildings house crafts such as weaving, pottery, woodworking, metalworking and leathercraft. There are many galleries showing the work of South Australian artists. The people of the Barossa invite visitors to share their past, with museums devoted to the days of early settlement and town history.

*Top: Antique shop, Tanunda.*
*Above: Barossa Valley buildings have traditionally been constructed by skilled stonemasons.*
*Left: "Down To Earth Pottery", Tanunda.*

27

*Top: The Heritage-listed Old Mill has been refurbished as guest accommodation, function rooms and restaurant.*
*Above: The German Arms Hotel, where the old and new worlds meet in Hahndorf.*

## Hahndorf in the Adelaide Hills

The green Adelaide Hills, with their fertile valleys, hold many lovely towns full of historic interest. Hahndorf was settled in 1839, by East Germans. They named their town after the captain of their ship, who had diligently searched for land for them. Today, Hahndorf proudly retains its German traditions. It was declared a State Heritage area in 1988 and its attractions include shops housed in historic stone buildings and many inns and restaurants, the Hahndorf Academy and St Michael's, which houses the oldest continuing Lutheran congregation in Australia. In January, Schuetzenfest is a time of feasting and fun and Hahndorf Founders Day celebrates the foundation of the town.

*Top: Hahndorf is one of the many fascinating towns in the Adelaide Hills.
Above: Sheep and vines flourish in the Adelaide Hills.*

29

## Whyalla

Whyalla, the largest regional city in South Australia, is known as "the gateway to the Eyre Peninsula". Situated on upper Spencer Gulf, it is not far from the iron-rich Middleback Ranges and its steelworks process iron ore from Iron Knob, fifty-two kilometres to the west. It looks to the sea and contains an excellent maritime museum. Fishing, yachting and windsurfing are popular local pastimes.

## Port Augusta

Port Augusta stands at the most northerly navigable point of Spencer Gulf. Once a major port for wool, wheat and minerals, it is now a railway and industrial centre, with National Railways workshops which service traffic from Perth, Adelaide, Sydney and Alice Springs. The ETSA "Northern" Power Station at Port Augusta produces around forty per cent of South Australia's power needs.

Top: "The Whyalla" was built in Whyalla in 1941 and is displayed at Whyalla Maritime Museum.
Above: Port Augusta stands at the head of Spencer Gulf.

## TOWARDS THE FLINDERS RANGES

Northeast of Port Augusta, on the road to the Flinders Ranges, Quorn is an old railway town which in 1956 was bypassed by the opening of a standard gauge line. The Pichi Richi railway line is one of the oldest intact railway systems in the world. It operates restored rolling stock from the original Ghan railway on a three-hour journey from Quorn through Pichi Richi Pass to Woolshed Flat. The last outpost before the Flinders Ranges is Hawker, once a busy centre for wheat farmers, whose hopes eventually vanished in successive dry seasons.

*Above left: The Mill, Quorn, on the way to the Flinders Ranges.*
*Above: The Fourway's Hotel, Quorn.*
*Left: The ruins of someone's hopes, near the town of Hawker.*
*Below: Pichi Richi line steam-engine ready to go.*

## THE EYRE PENINSULA

Named after Edward John Eyre, who traversed it in 1840, this peninsula produces around ten per cent of Australia's wheat crop, but contains much natural bush and offers great diversity in landscapes. Nearly half the area of the peninsula is set aside as reserves, parks and native bushlands. Its eastern coasts feature sandy beaches and fishing harbours, while its western aspects contain rugged coastal scenes sculpted by the Southern Ocean. On the southwest of the Eyre Peninsula, Coffin Bay National Park offers especially beautiful and unspoilt coastal wilderness.

*Above: The extensive eastern beaches of the Eyre Peninsula are ideal for anglers.*
*Right: Sunset on the Southern Ocean, Coffin Bay National Park.*

## Port Lincoln

Port Lincoln stands on a superb natural harbour and is home to Australia's largest commercial tuna fleet. Navigator Matthew Flinders visited Boston Bay in 1802 and named Port Lincoln after his native Lincolnshire. Twenty kilometres south of Port Lincoln is Lincoln National Park, which contains both quiet bays ideal for camping and stretches of wild, exposed coastline.

*Above: Sunrise at Port Lincoln, named by Matthew Flinders.*
*Right: Lincoln National Park is just south of Port Lincoln.*

## A MAGNIFICENT COASTLINE

West of Port Lincoln, Coffin Bay National Park covers 30,380 hectares of the Coffin Bay Peninsula and contains some magnificent coastal wilderness. Several scenic drives lead through the park, which is home to a great variety of wildlife, particularly seabirds. Southern Right Whales visit these waters between June and October, on their annual breeding migration.

*Above: Cape Carnot is southwest of Port Lincoln.*
*Left: One of Coffin Bay National Park's magnificent beaches.*

36

## NULLARBOR PLAIN

The word Nullarbor means "no trees", though there are some stunted trees on this vast plain. Once this area lay under the sea. Earth movements pushed it upwards to form an expanse of limestone, beneath whose surface are extensive cave systems, ending at the Great Australian Bight in precipitous cliffs. The Plain has its own interesting wildlife: like many other arid-country creatures, the Southern Hairy-nosed Wombat escapes from the daytime heat by living in a burrow. The Trans-Australia Railway crosses the plain and tiny settlements named after past Prime Ministers of Australia, housing maintenance workers, are scattered along its length.

*Left: Mulga trees at sunset on the eastern Nullarbor Plain. Top left to right: Salt lakes, Nullarbor National Park; sheer seacliffs border the Great Australian Bight; bluebush and other drought-tolerant plants grow on the arid Nullarbor; bound for Western Australia across the Nullarbor; travelling musicians entertaining school children at Cook, on the Trans-Australia Railway; historic cells at Cook, on the Trans-Australia Railway. Below: The Southern Hairy-nosed Wombat, faunal symbol of South Australia, lives in burrows on the Nullarbor Plain.*

## The Flinders Ranges

Flinders Ranges National Park protects a large area of the scenic Central Flinders Ranges, with their mountain scenery, peaceful tree-lined gorges, wildlife and seasonal displays of wildflowers. The Gammon Ranges National Park features the stark and rugged wilderness of the North Flinders Ranges. Aboriginal people lived in the area for at least 10,000 years before European settlers attempted to establish agriculture or pastoral leases. Poor seasons forced abandonment of many properties and today, the ranges, with their changing colours and challenging peaks, are a mecca for bushwalkers, campers and photographers.

*Left: Magnificent river red gums grow along the Flinders Ranges watercourses.*
*Above: The Common Wallaroo can be seen in the Flinders Ranges.*

## Ranges of changing colour

Sir Hans Heysen and many other artists have marvelled at the transformations in colour undergone by the Flinders Ranges. Stark and rugged, they rise from the plains, changing from purples and blues to brown-golds and dusky reds in response to time of day and weather conditions. After rainfall, less precipitous slopes are bright with green and multi-coloured wildflowers.

*Left: The Flinders Ranges rise from rolling plains crossed by tree-lined creek beds.*
*Above: The dramatic Flinders Ranges National Park is four to five hours' drive north of Adelaide.*
*Below: An aerial view of Wilpena Pound, an immense elevated amphitheatre enclosed by cliffs of quartzite and sandstone.*

# Outback South Australia

**M**aking a living in the Outback of South Australia, the driest State in a dry continent, is not easy. South Australia's Outback contains eighty per cent of the State's area and less than three-quarters of one per cent of its population. Some of its inhabitants survive due to a combination of hard work, good luck and good seasons. Others do the hard work, but miss out on the luck, and suffer a run of poor seasons. Either way, making the best of what you have is one of the keys to survival in this arid country. The people of the Outback are friendly and hospitable and the land itself is fascinating. Travel here taking proper precautions and treat the fragile environment with care and consideration.

*Above right: The ruins of Lake Harry homestead, on the Birdsville Track, northeast South Australia.*
*Right: Alfrinck carves talc stone in his studio at Lyndhurst, in the heart of South Australia.*

## The Ghan railway

The Ghan railway was named after the Afghan camel-men whose beasts carted loads through the Outback. It ran from Port Augusta, north through the Outback of South Australia to Alice Springs, in the Northern Territory. Travel on the Old Ghan line was sometimes adventurous, especially if flash floods isolated the train - once the engine driver had to shoot goats to feed his passengers! The Old Ghan was closed in 1980 and in 1983, the line was removed. It was replaced with a faster, wider gauge several hundred kilometres to the west. Today, the ruins of stations, settlers' cottages and bridges mark the original route.

Above: A poster advertising the old Ghan railway.
Above left: Once this was a railway siding on the old Ghan line.
Left: Tearing up the tracks of the famous Ghan railway, in 1983.

## NORTHWEST FROM PORT AUGUSTA

Oodnadatta, Mintabie, Innamincka, William Creek, Coober Pedy - these are names that conjure up visions of vast distances, isolated homesteads, arid landscapes and warm hospitality at the end of each day's journey. Northwest from Port Augusta is Woomera, once Australia's link with the space-age. Northwest again is the remarkable mining town of Coober Pedy, where a moonscape of craters marks miners' search for opal and humans live underground, shielded from the sun. The name "Coober Pedy" is derived from the Aboriginal *kapu piti*, meaning "man's ground-hollow". The traveller in this area should carry adequate supplies of water, the most precious resource in Australia's Outback.

*Opposite above: Target plane and rocket at Woomera, once a testing station for British rockets and a NASA tracking station.*
*Opposite below: Picnic races at William Creek, the State's smallest town.*
*Above: Opal was discovered at Coober Pedy in 1915.*
*Right: Living underground to escape the heat is a common practice in Coober Pedy.*

45

46

### The northern sandy deserts

A group of extensive national parks guards the fragile environments of South Australia's northern areas. The Simpson Desert Regional Reserve and Simpson Desert Conservation Park, west of the Birdsville Track and extending into Queensland and the Northern Territory, include a seemingly endless series of red sand dunes, salt lakes, spinifex grass and gidgee woodlands. After rare rainfall, the desert plants sprout leaves and flowers and set seed, which will endure through succeeding dry years.

*Above left: The north of South Australia contains vast sandy deserts.*
*Far left: The Central Netted Dragon survives in dry, sandy areas.*
*Centre left: Galahs are found near water in Australia's arid country.*
*Left: The Thorny Devil feeds on ants.*
*Above: After rain, the plants of the sandy desert blossom profusely.*

48

## RIVERLAND AND MURRAYLANDS

In 1887, irrigation was introduced to the Murray River where it flows westwards from the Victorian border through South Australia. The area, today known as the Riverland, or "South Australia's Orchard", became an eden for citrus fruit, grapes and vegetables. After the Murray turns southwards at the town of Morgan, it winds through the Murraylands, where wildlife and watersports, houseboats and heritage trails are key attractions.

*Above left to right : School children at Morgan, where the Murray River turns southwards; high cliffs of sandy limestone shelter the Murray at Walker Flat; annual fun run at Murray Bridge, hub of the Murraylands.*
*Left: The Murray River near the town of Nildottie.*
*Right: Shrimp fisherman on Lake Alexandrina.*

49

*Above: The Australian Pelican is common where the Murray flows to the Southern Ocean near the Coorong National Park.
Opposite: above left and right: The River Murray near Barmera; Waikerie attracts gliding enthusiasts from all over the world
Opposite: below left and right: A houseboat passes Murray River cliffs at Walker Flat; the Murray backwaters are ideal places to watch birds.*

*The Murray River cliffs near Walker Flat appear gold in the sunset glow. Watersports are popular in this stretch of the river.*

# Kangaroo Island

Kangaroo Island, the third-largest island off the coast of Australia, is approximately 160 km by 60 km. It was visited by Matthew Flinders in 1802. In the following year, the French visited and American sealers stayed at American River for four months, during the time building South Australia's first boat, the *Independence*. The barque *Duke of York* landed South Australia's first British settlers at Nepean Bay on Kangaroo Island, on 27 July 1836 and was soon joined by other ships. Today, the wildlife of Kangaroo Island is a particular drawcard for visitors and the colony of Australian Sea-lions at Seal Bay Conservation Park attracts many visitors. Other reserves noted for wildlife and scenery are Flinders Chase National Park and Kelly Hill Conservation Park. The island is a short flight from Adelaide and ferries regularly ply between Penneshaw on the mainland and Kingscote and Cape Jervis.

*Far left: Pennington Bay, in Kangaroo Island's southeast, is a fine surf beach.*
*Left: Australian Sea-lion at Seal Bay Conservation Park.*
*Below: There are about 500 Australian Sea-lions at Seal Bay.*

*Above: Flinders Chase is considered by many to be South Australia's most important National Park, due to its natural state, its wildlife and its lack of introduced predators.*
*Far left: The Tammar Wallaby can be seen on Kangaroo Island.*
*Left: Touring Flinders Chase National Park*

## KANGAROO ISLAND'S SOUTHWEST

The most popular tour on Kangaroo Island takes the traveller from Kingscote to Seal Bay, thence to Kelly Hill Conservation Park, then to Cape de Couedic, with its lighthouse and Admirals Arch, and finally to enjoy the scenic features and wildlife of Flinders Chase National Park.

*Above: The building materials for Cape de Couedic lighthouse were hauled to the top of the cliffs by flying fox.*
*Above right: Caves of ornate calcite formations are a popular attraction at Kelly Hill Conservation Park.*
*Centre right: Admirals Arch, at Cape de Couedic.*
*Right: Cape de Couedic juts into the Southern Ocean.*

## Remarkable Rocks

On the dome of Kirkpatrick Point, to the east of Cape de Couedic, stands the group of huge, weather-sculptured boulders known as Remarkable Rocks. Their sides have been undercut by caverns (or tafoni) thought to be caused by the crystallisation of salts within the structure of the rock itself. Their rich reds are the natural colour of ironstone; lichens form contrasting streaks of orange and grey-green.

## VICTOR HARBOR

Victor Harbor, 83 kilometres south of Adelaide, was once a major port for the Murray River trade and is now a leading tourist resort. The area was first settled in 1837 and Governor Hindmarsh favoured the site, known at the time as Alexandra, for the colony's capital. A railway eventually linked Goolwa, on the lower reaches of the Murray River, and Victor Harbor, but the town's role as a major port for the Murray trade eventually diminished. Today, the Cockle Train gives a scenic ride between Victor Harbor and Goolwa. The one-kilometre trip across a causeway from Victor Harbor to Granite Island, a wildlife sanctuary noted for its Fairy Penguins, can be made on a horse-drawn tram.

*Above right: Victor Harbor, first called Alexandra, was settled in 1837 to service the whaling industry.*
*Right: The Savings Bank of South Australia was established in 1848. This branch stands in Victor Harbor.*
*Below: The Telegraph Station Gallery, Victor Harbor*
*Opposite: A horse-drawn tram travels from Victor Harbor to Granite Island*

## The southeast coast

The southeast of South Australia contains some magnificent coastal scenery. Fishing is an important occupation and a holiday attraction along the coast between Kingston and Port MacDonnell. The magnificent wilderness of the Coorong and other wetland habitats towards the mouth of the Murray River offer great opportunities to observe wildlife, especially birds.

*Above: Crayfisherman at Kingston, on the "Crustacean Coast".*

*Above right: Cape Northumberland at Port MacDonnell, with Cape Northumberland Lighthouse at top left.*

*Right: Fishing is a major occupation at Kingston, Robe, Beachport and Port MacDonnell.*

## LAKES, CAVES AND VOLCANOES

As well as fertile farmland, the southeast of South Australia contains notable subterranean caves, scenic lakes and extinct volcanoes. The famous Blue Lake at Mount Gambier occupies an ancient crater. Three kilometres in circumference, the lake changes colour from dull grey in winter to deep blue in November. This is an area of reliable rainfall, with warm summers and cool to mild winters.

*Above left: Blue Lake, which lies in the crater of an extinct volcano, changes colour from grey in winter to intense blue in summer.*

*Above: Mount Gambier stands on the slopes of an ancient volcano. Its streets contain many fine examples of colonial architecture built in local stone.*

*Left: Rural countryside near Mount Gambier.*

# A HISTORY OF
# SOUTH AUSTRALIA

The Aboriginal people lived in many parts of South Australia for thousands of years before the coming of Europeans.

In early 1802, Captain Matthew Flinders in H.M.S. Investigator surveyed Port Lincoln and Spencer Gulf, sighted Mount Lofty from Kangaroo Head on Kangaroo Island, then explored Gulf St Vincent.

The foundation of the province of South Australia, after three decades in which sealers were the main visitors to its coasts, resulted from the theory of Edward Gibbon Wakefield that colonial land should be sold at "a sufficient price" to finance the migration of Britain's excess population. In October 1835, the South Australian Company was formed. Colonel William Light was appointed Surveyor General of South Australia, while Captain John Hindmarsh was appointed Governor. H.M.S. *Buffalo*, bringing the Governor and some 170 passengers, arrived at Holdfast Bay on 28 December, 1836. After extensive exploration, Surveyor General Light had decided upon the site for Adelaide and confirmed his choice despite Hindmarsh's objections. By 7 February, 1837, Light had prepared a coloured map of Adelaide and noted, "the dark green round the town I proposed to the Resident Commissioner to be reserved as Park Lands". This foresight was to play a large part in making Adelaide the delightful, green-girdled city it is today.

Governor Hindmarsh was replaced by Governor Gawler, then, in 1841, the efficient George Grey took over as Governor. The colony's financial position improved dramatically in the 1840s with the exploitation of silver-lead and of copper from Burra and Kapunda and later, in the 1860s, from Wallaroo and Moonta. While mining brought spectacular wealth, the profits from wheat, wool and wine grew steadily. Today, South Australia's chief exports are wool, wheat and minerals, while its wine exports continue to grow in quantity and in acclaim.

South Australia was established without convicts and many of the early European settlers were religious non-conformists. The State has a history of political and social innovation (it was the first Australian State to introduce votes for women, in 1894 and appointed the first Aboriginal State Governor and the first female State Governor). Multiculturalism has been welcomed and artistic development and diversity encouraged, so that festivals and celebrations are typical of "the Festival State".